
Copyright © 2019 by Prajanyaa Publication
All rights reserved.

No part of this publication or the information in it may be quoted from or reproduced in any form by means such as printing, scanning, photocopying or otherwise without prior written permission of the copyright holder.

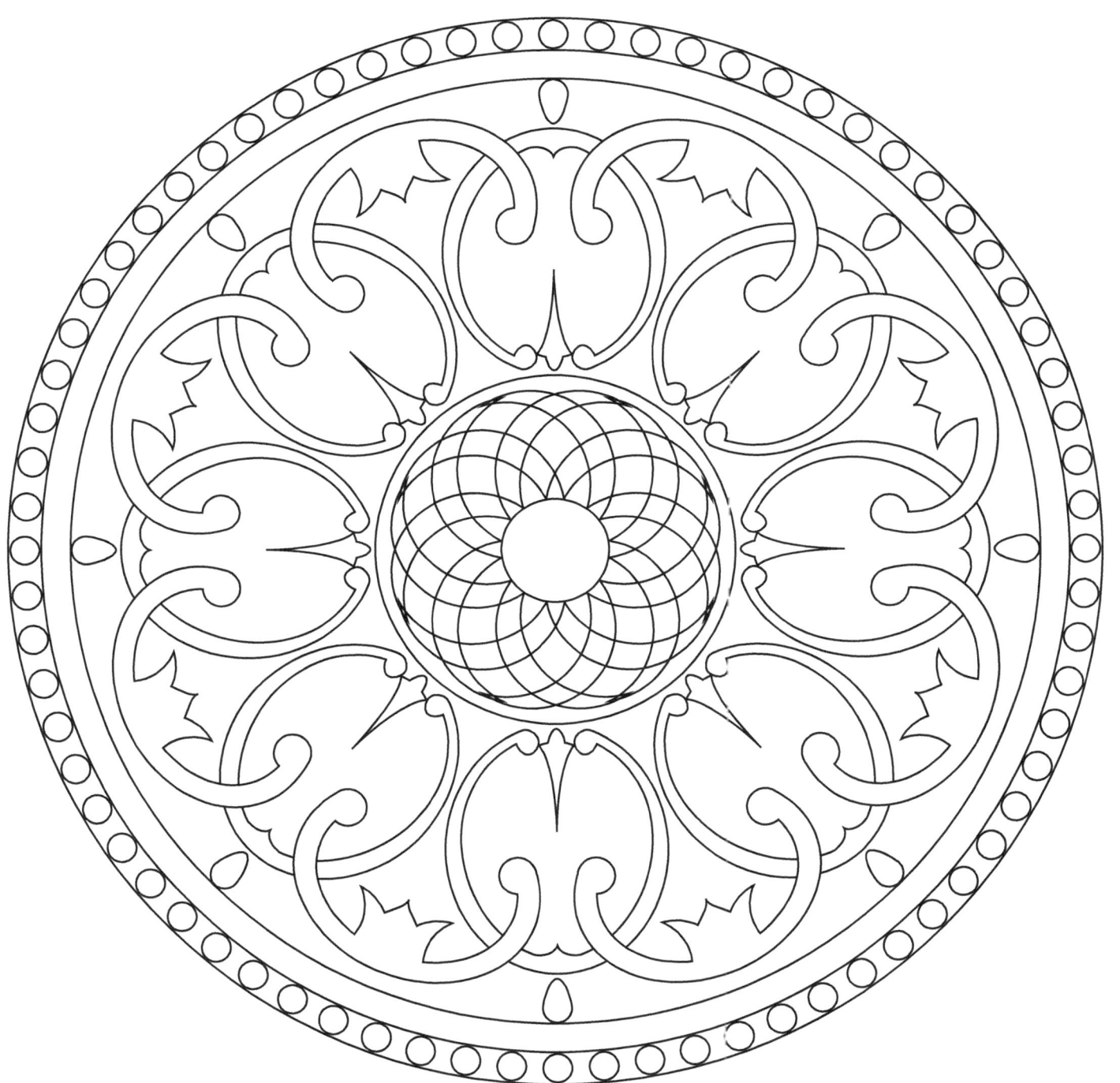

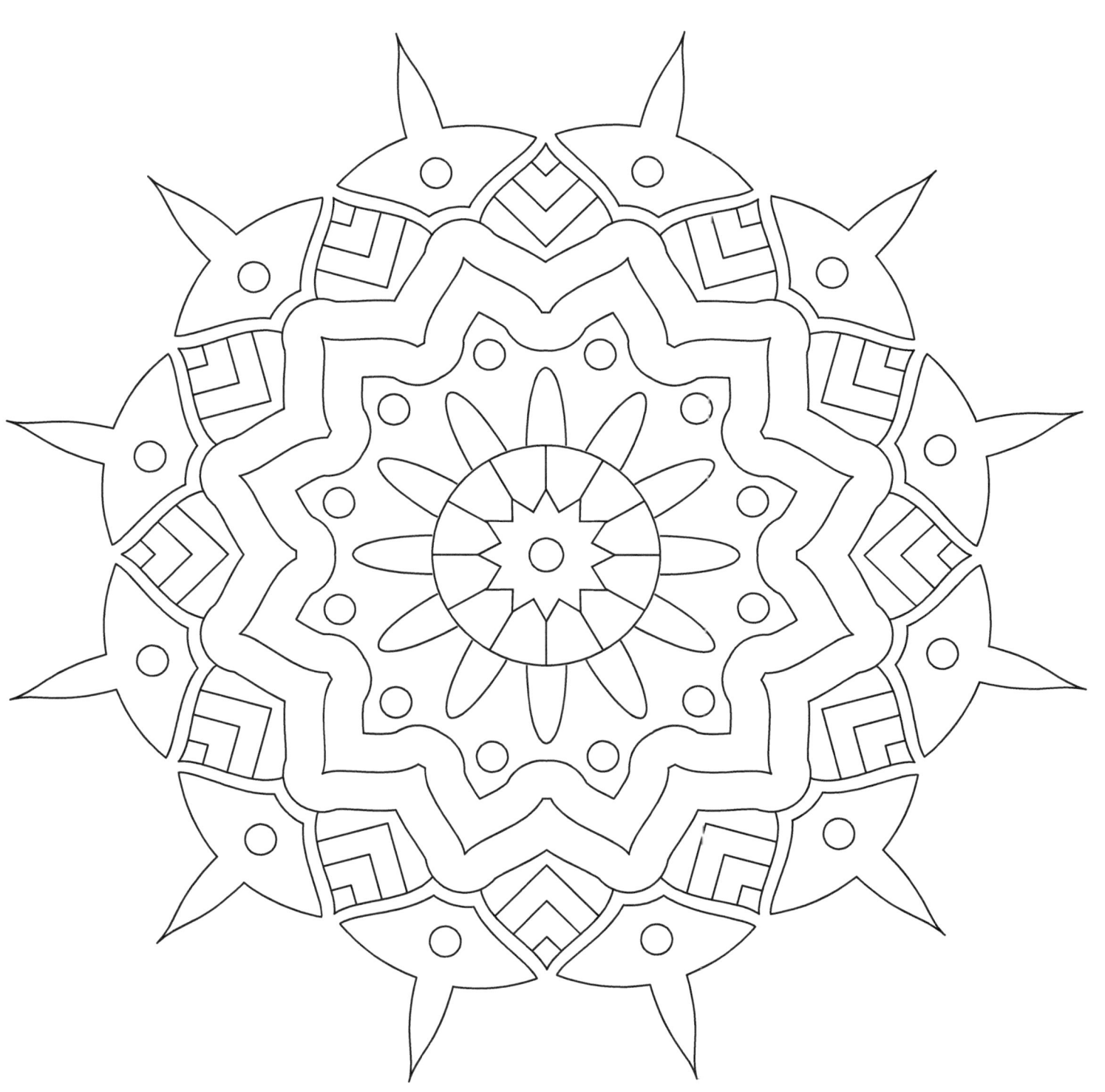

www.ingramcontent.com/pod-product-compliance
Lightning Source LLC
Chambersburg PA
CBHW080603220526
45466CB00010B/3235